Mike Kelley Gallery

The Nature of Things

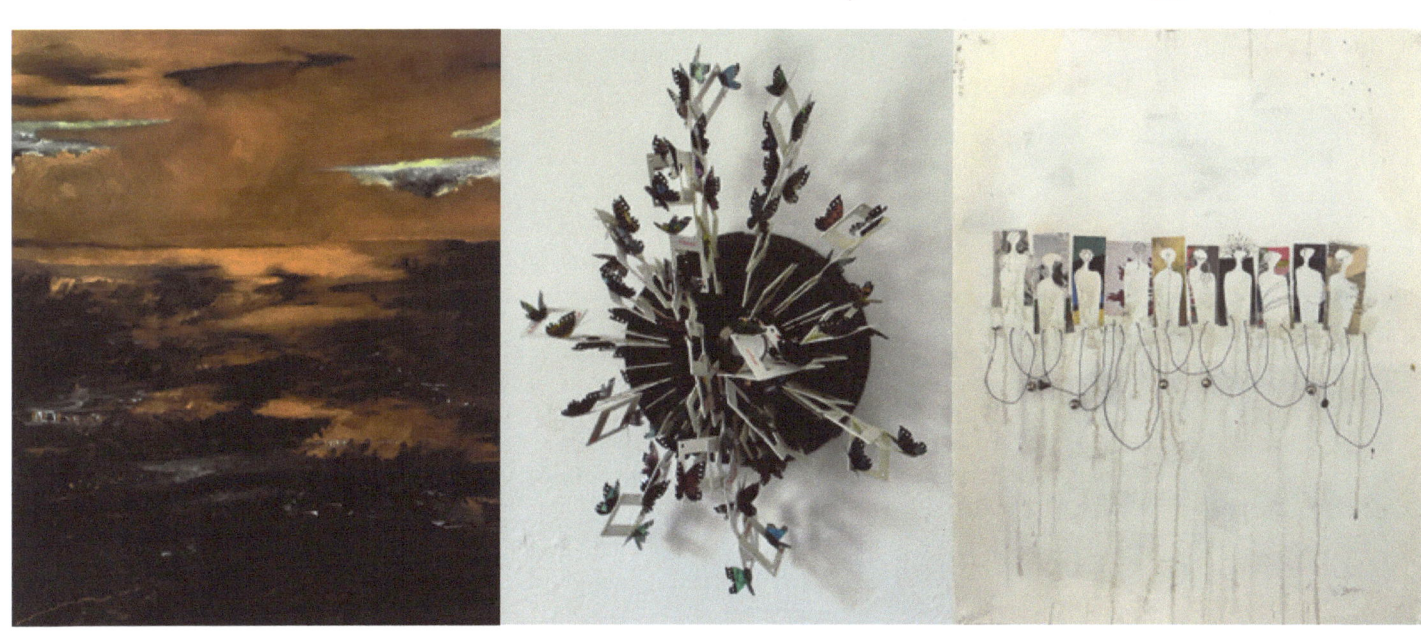

Gallery A: Lillian Abel, "Energy"

Gallery B: Tracey Weiss, "Metamorphosis"

Gallery C: Karrie Ross, "Balance & Flow"

June, 2017

The Nature of Things

Copyright © 2017 Karrie Ross

All rights reserved. Except as permitted under U.S. Copyright Act of 1976, no part of this publication may be reproduced, distributed, or transmitted in any form or by any means, or stored in a database or retrieval system, without the prior written permission of the publisher.

Karrie Ross: 708 W. 140th Street, Gardena, CA 90347
Visit her website at www.KarrieRoss.com.

Image use is prohibited without written concent of the artists. All art copyright respective artist.
Printed in the United States of America
Catalog Design by Karrie Ross

Mike Kelley Gallery Presents

The Nature of Things

THE MIKE KELLEY GALLERY INVITES THREE ARTISTS to celebrate "The Nature of Things". In a world currently filled with uncertainties the attention to 'all things Nature' allows us a freedom of, and connection to the differences in our world. Each day we are called on to make choices about how to live, to be. A showing-up for the not so simple phenomena of the physical world, landscapes, animals, plants; the not so easy human condition man-made structures, social rules; and the never superficial inherent beauty of things—their sense of magic. Each with a language of its own when perception gets a hold on our soul, and we can't look away from what they demand of us. Art has a way of saving "things" from extinction, even if it's just a simple, easy, depth of a new color, sound, distraction from—there is nothing so compelling when it comes to an artistic view.

 Gallery A: Lillian Abel, "Energy"

 Gallery B: Tracey Weiss, "Metamorphosis"

 Gallery C: Karrie Ross, "Balance & Flow"

The Mike Kelley Gallery is part of historic Beyond Baroque, one of the United States' leading independent Literary / Arts Centers and public spaces dedicated to expanding the public's knowledge of art, poetry, and literature through cultural events and community interaction. Founded in 1968, Beyond Baroque is based out of the original City Hall building in Venice, California.

Visit their website at. http://www.beyondbaroque.org

June, 2017

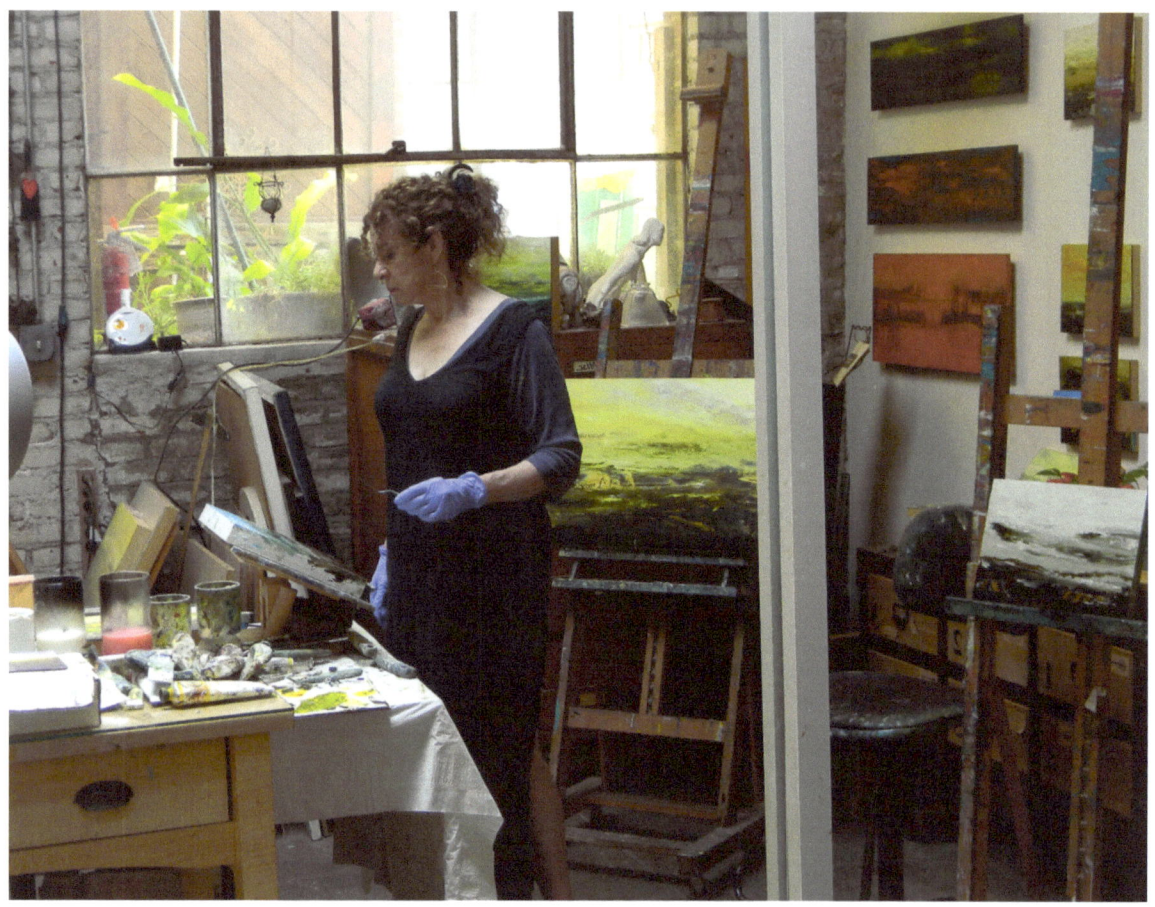

The Nature of Things

Lillian Abel

Gallery A:

"Energy" My work depicts Nature, however, it is made in my studio from memory, impulse and emotions. They are abstracted by the palette knife, searching for hidden worlds and images in the paint that reveal on the picture plane. They need to be uncovered, stroked, massaged and moved onto the surface, brought up from where they are hiding; surprising me with their ability to come forth when called by my hand. Revealing the recognized of our 'world sight' as unrecognizable, opening the eye of the witness to the experienced memory of the coalescence of fierceness and delicacy in the wilderness. Beginning from the darkness, moving to find hidden worlds that lay just beyond the edge of our awareness, calling the unexplored knowledge of the unseen.

Lillian Abel is a Los Angeles based artist who creates paintings that provoke a response to the unknown.

www.lillianabel.com

June, 2017

Lillian Abel

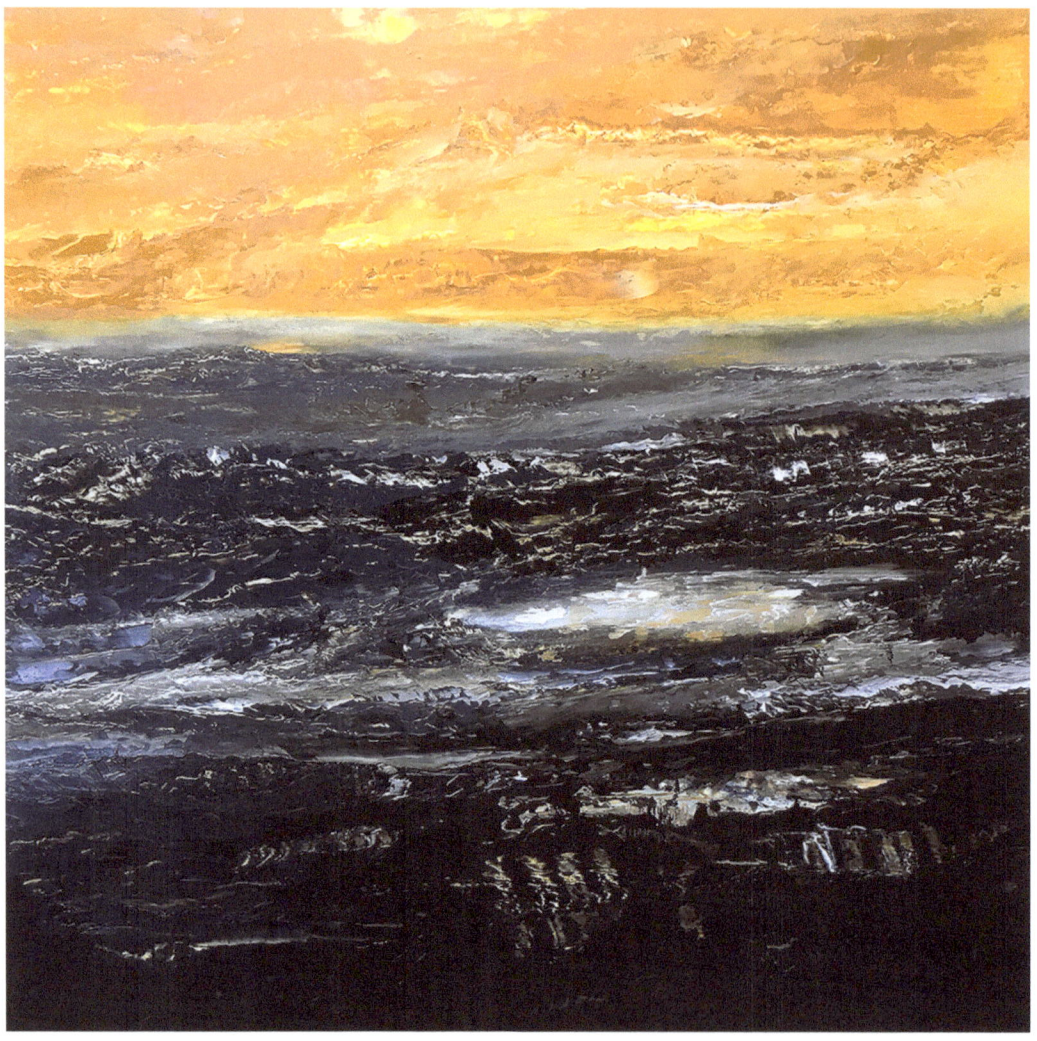

Luciferous
Oil on Wood
30" x 30"
2017

The Nature of Things

Lillian Abel

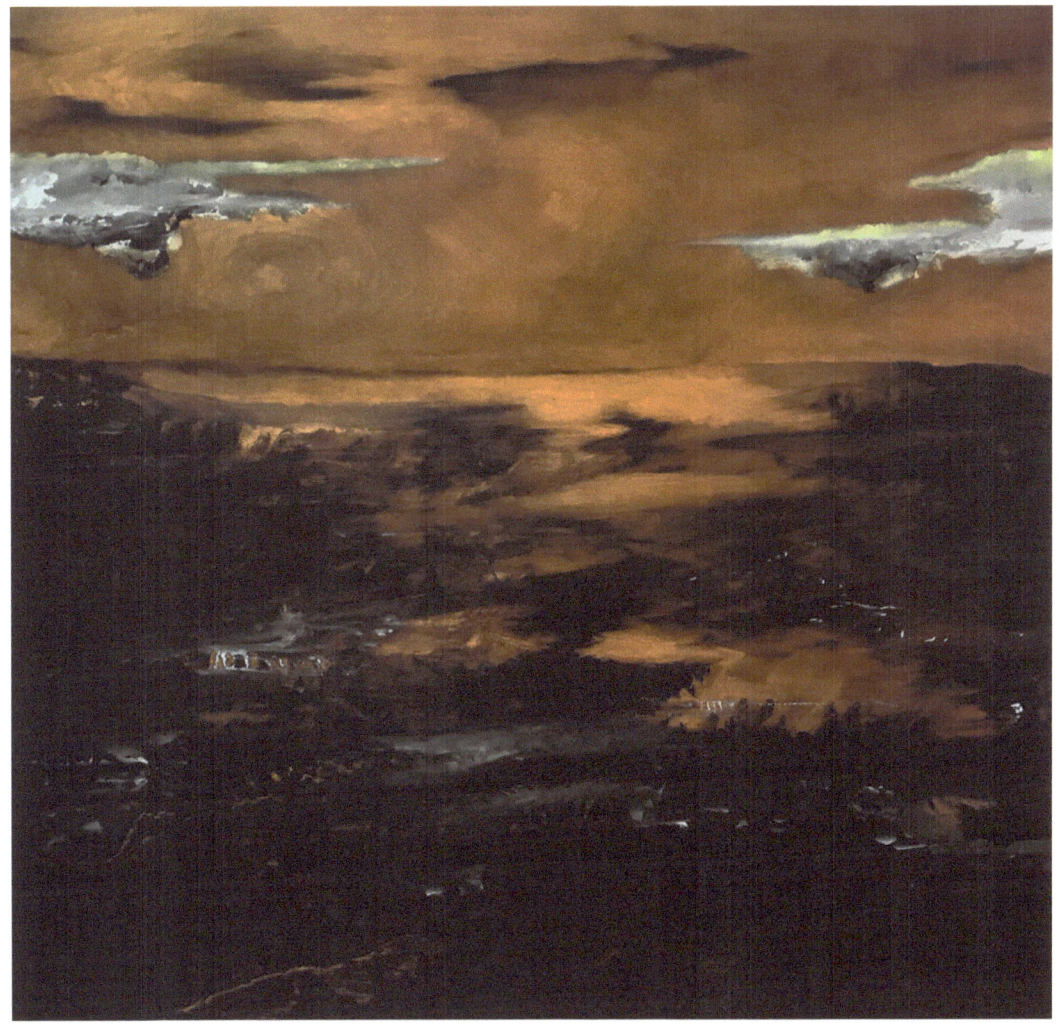

Untitled, April 29, 2017
Oil on Wood
30" x 30"
2017

June, 2017

Lillian Abel

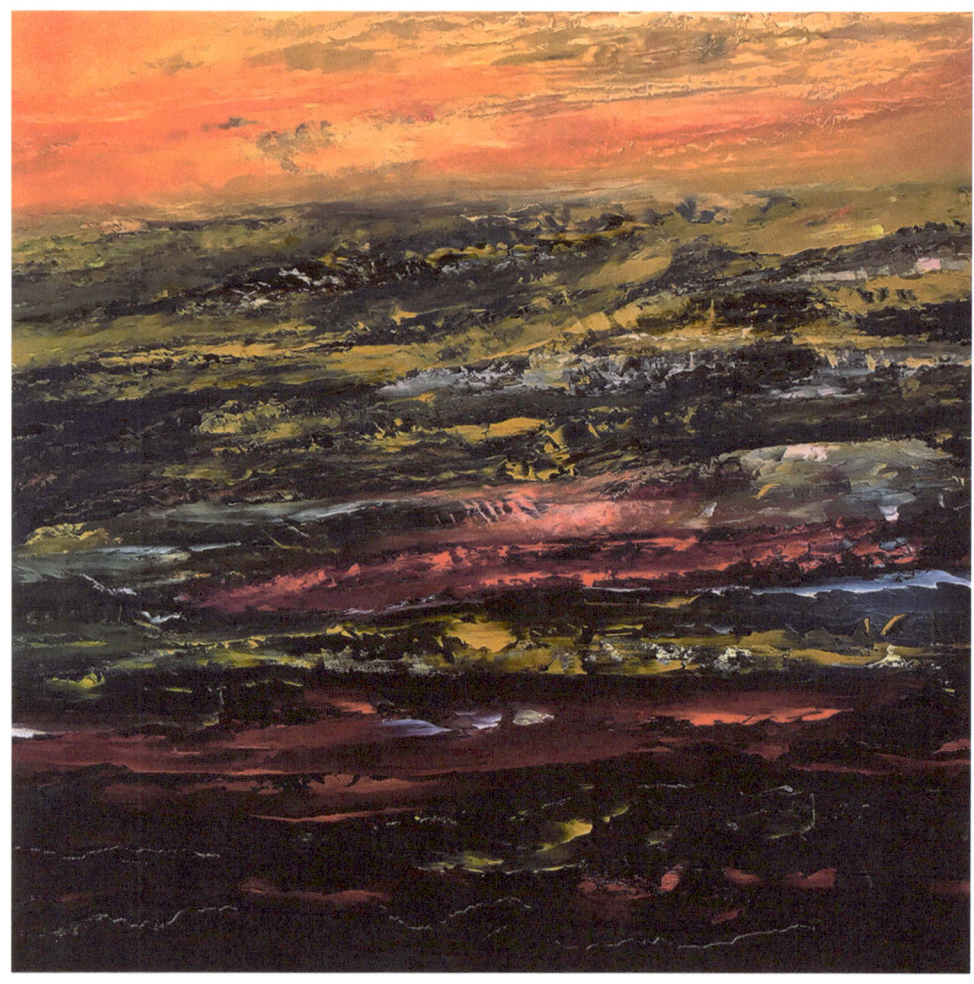

Through, Far and Below
Oil on Wood
30" x 30"
2017

The Nature of Things

Lillian Abel

It Is As It Is In Everything No. 3
Oil on Wood
9" x 12"
2016

The Thing In Itself
Oil on Wood
8" x 10"
2016

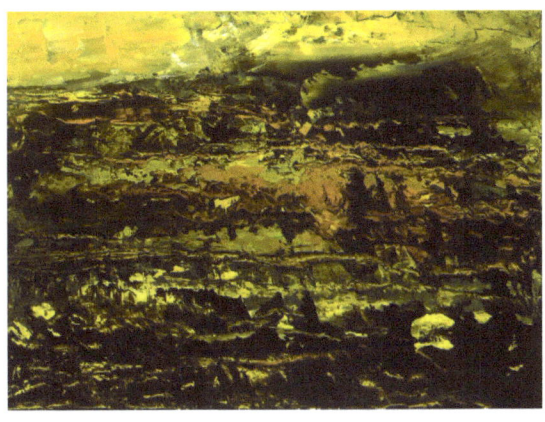

Revealed
Oil on Wood
9" x 12"
2016

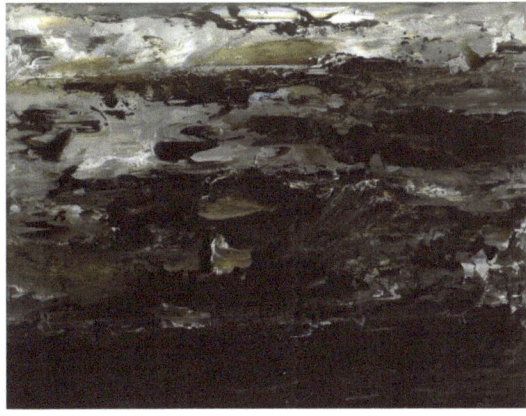

Reflection No. 3
Oil on Wood
8" x 10"
2016

June, 2017

Lillian Abel

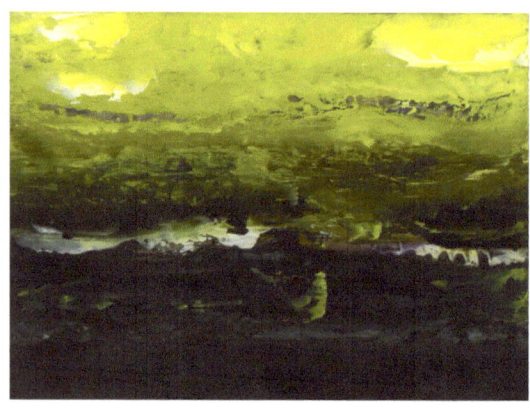 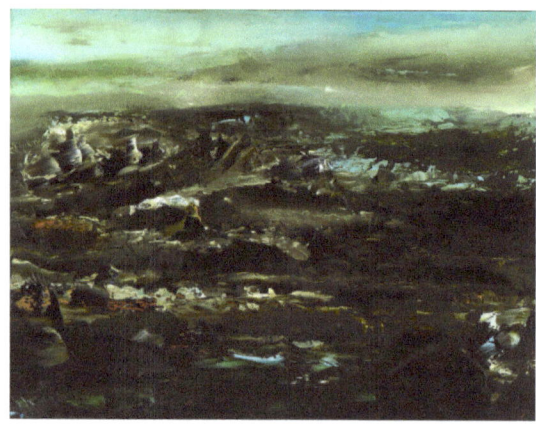

Doors of Perception
Oil on Wood
9" x 12"
2017

Oneiric Season
Oil on Wood
11" x 14"
2017

The Nature of Things

Lillian Abel

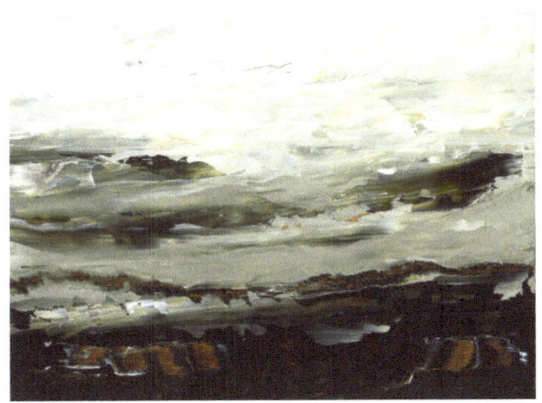
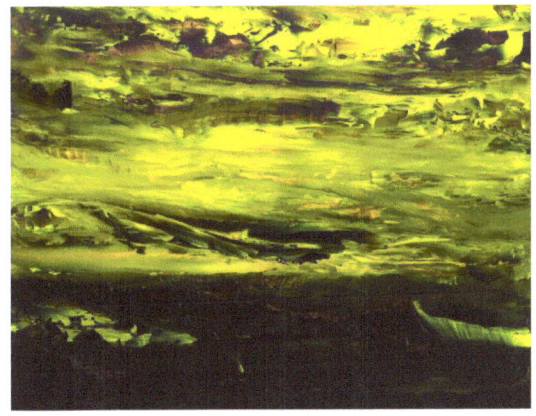

Arctic Wind
Oil on Wood
9" x 12"
2017

Oneiric Interlude
Oil on Wood
11" x 14"
2017

June, 2017

Lillian Abel

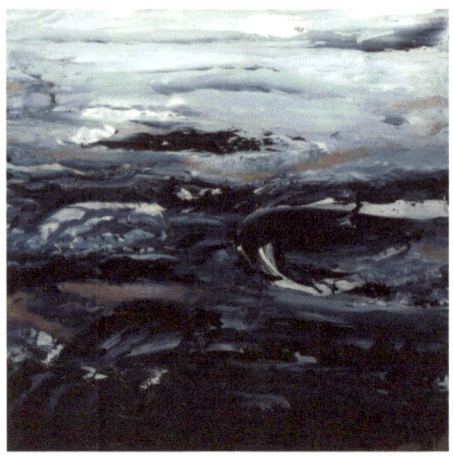

Through, Between and Around
Oil on Wood
12" x 12"
2016

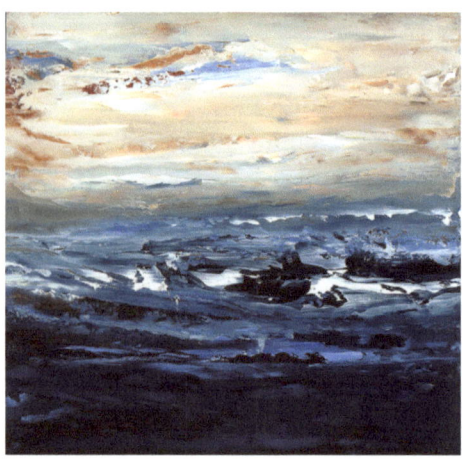

Everything Is and Isn't
Oil on Wood
12" x 12"
2016

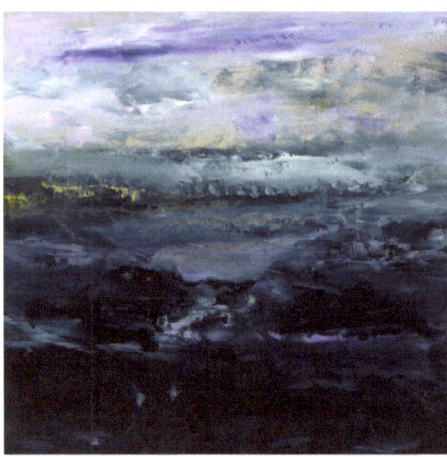

The Thing In Itself No. 2
Oil on Wood
12" x 12"
2016

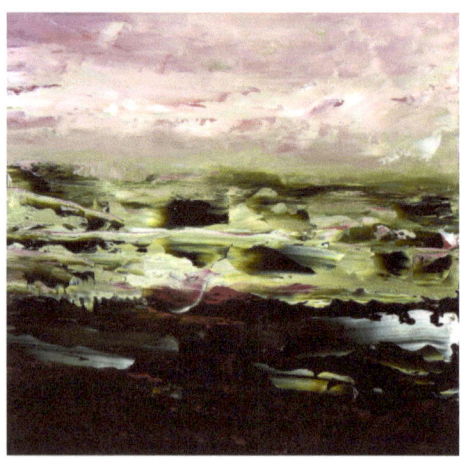

Everything Is and Isn't No.2
Oil on Wood
12" x 12"
2016

The Nature of Things

Lillian Abel

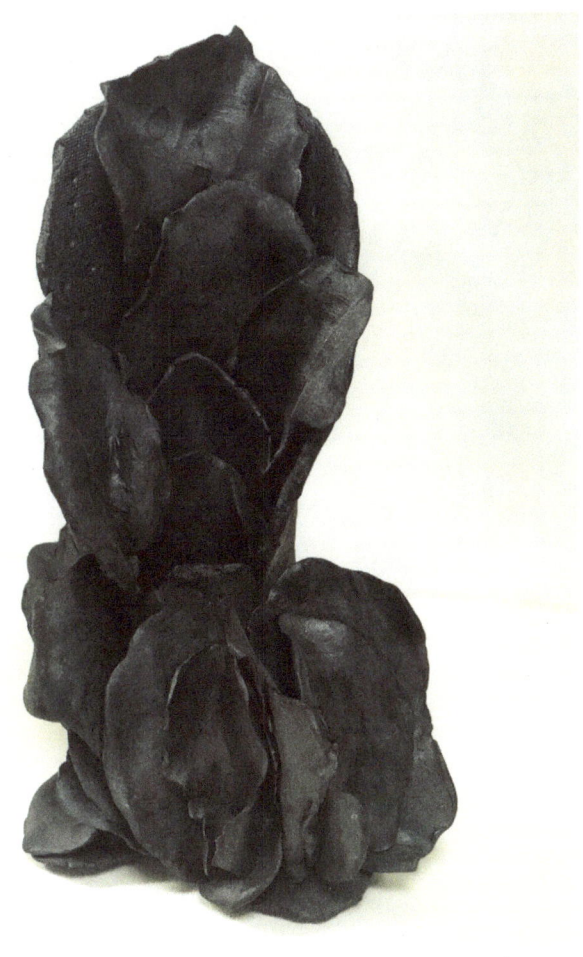

Efflorescent Occurrence
Ceramic with Oxide Stain
9" x 5"
2016

June, 2017

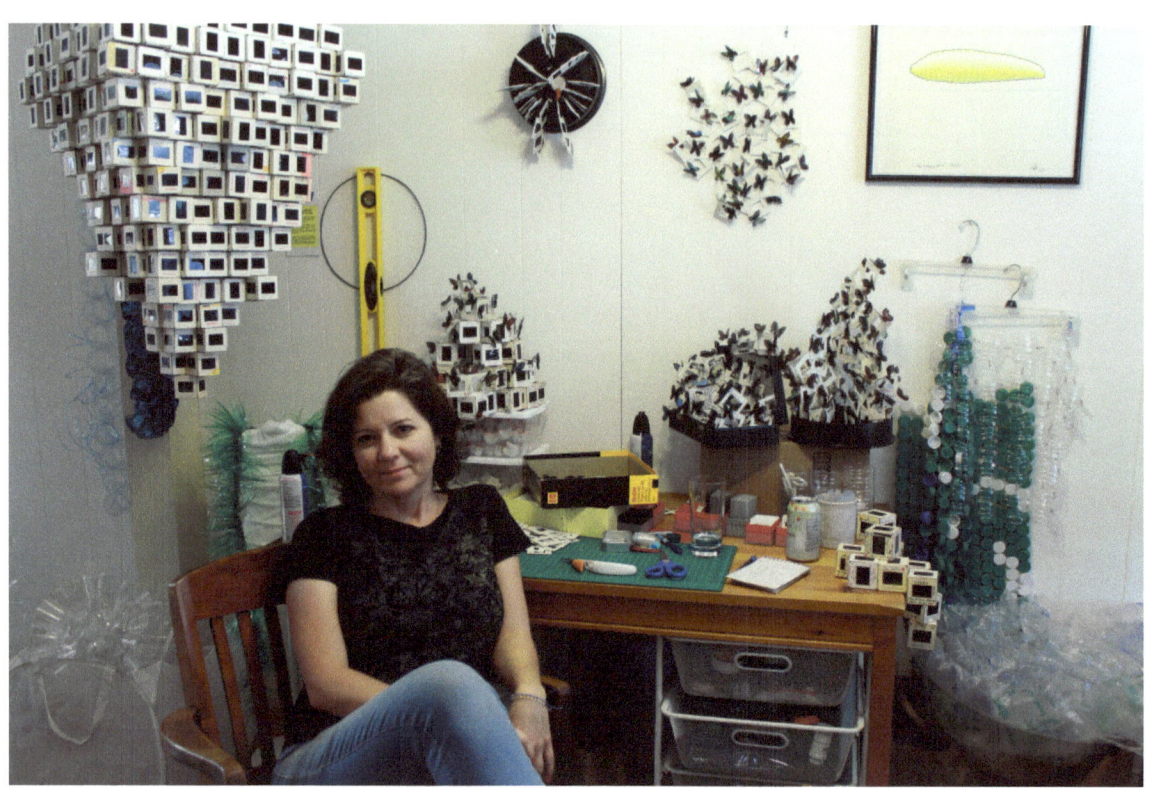

The Nature of Things

Tracey Weiss

Gallery B:

"Metamorphosis" is an investigation into the innate cycle of nature, as well as our own society. Seasons, life cycles, survival of the fittest: these are all terms we come to know as relating to wildlife, ecology, and the natural world around us. These terms also play an important role in our man-made world of industry, advancement, and even sociology. While 35mm slides left the mainstream in the late 1970s as every household's record of their summer vacation, slide film had an extended life in the art world and academia. Artists' portfolios were captured in slides well into the late 1990's and even into the early 21st century for some. Since the digital film has taken over, slide portfolios and slide libraries have been collecting dust in artist studios and educational institutions everywhere. In the work in "Metamorphosis", viewers are invited to view these miniature, framed images as objects unto themselves, evolving from an outdated photography medium to a new sculpture medium.

Tracey Weiss is a Long Beach based artist who creates sculpture from found objects, as well as ceramics.

www.traceyweissart.com

June, 2017

Tracey Weiss

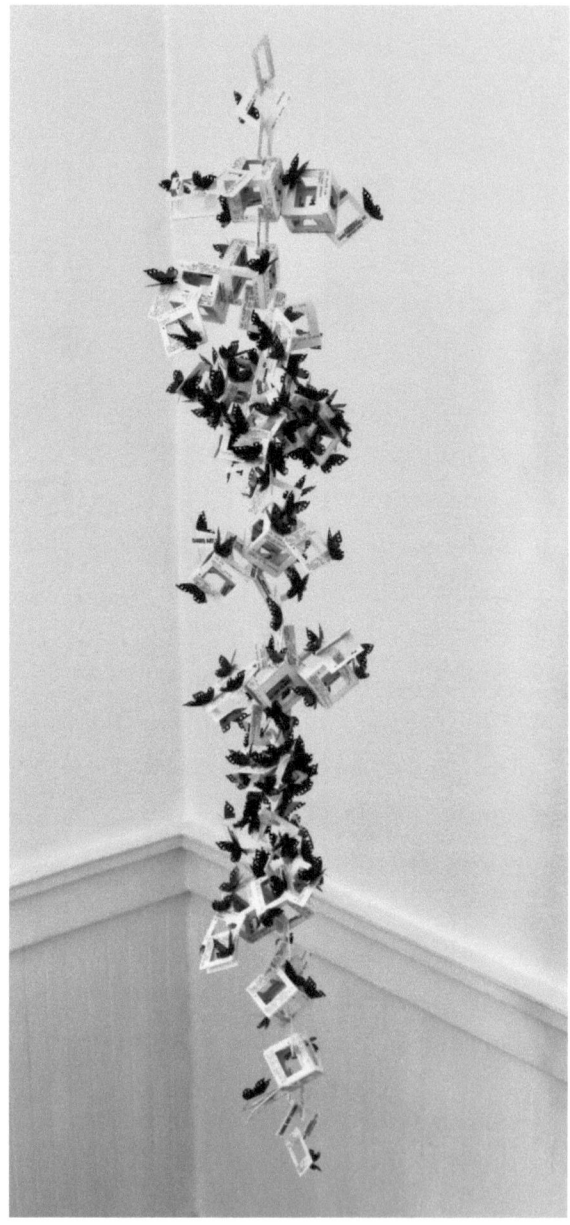

Swarm
film, slide holders
2017

The Nature of Things

Tracey Weiss

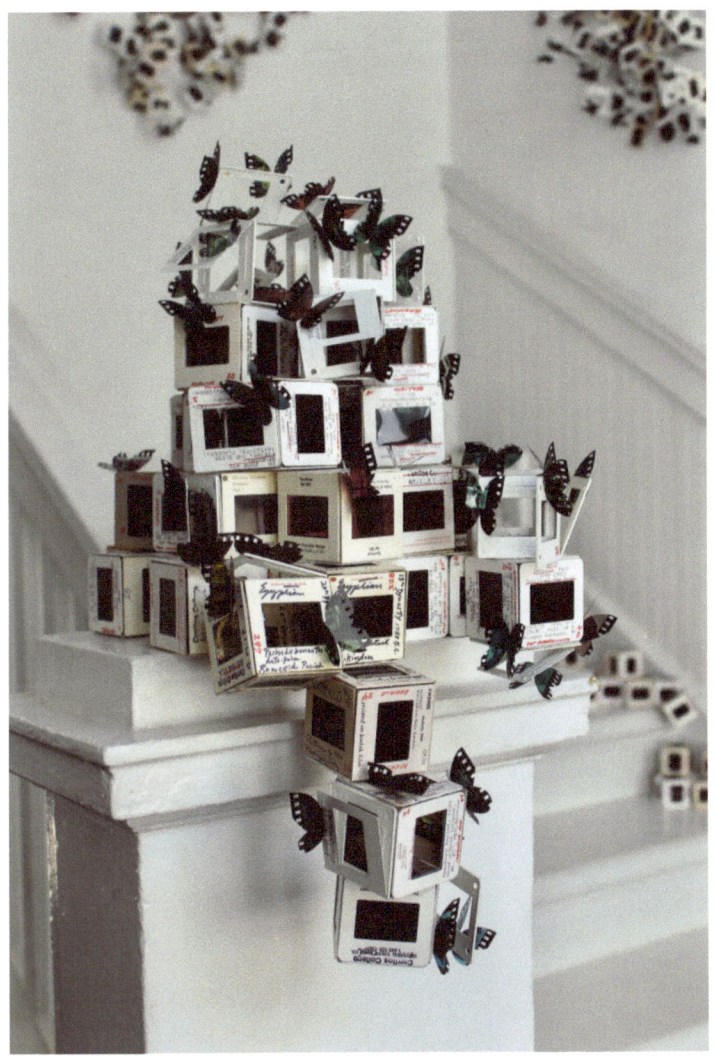

Toppled
film, slide holders
2017

June, 2017

Tracey Weiss

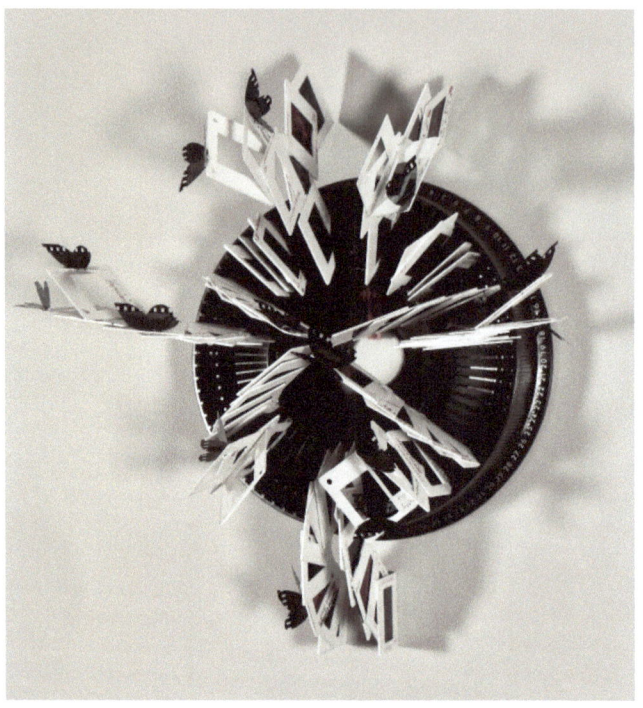
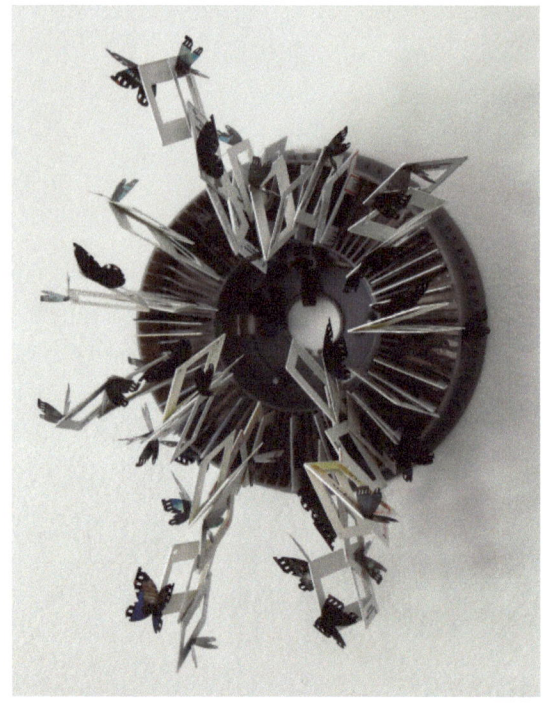

Departure 1
film, slide holders and carosel
2017

Departure 2
film, slide holders and carosel
2017

Tracey Weiss

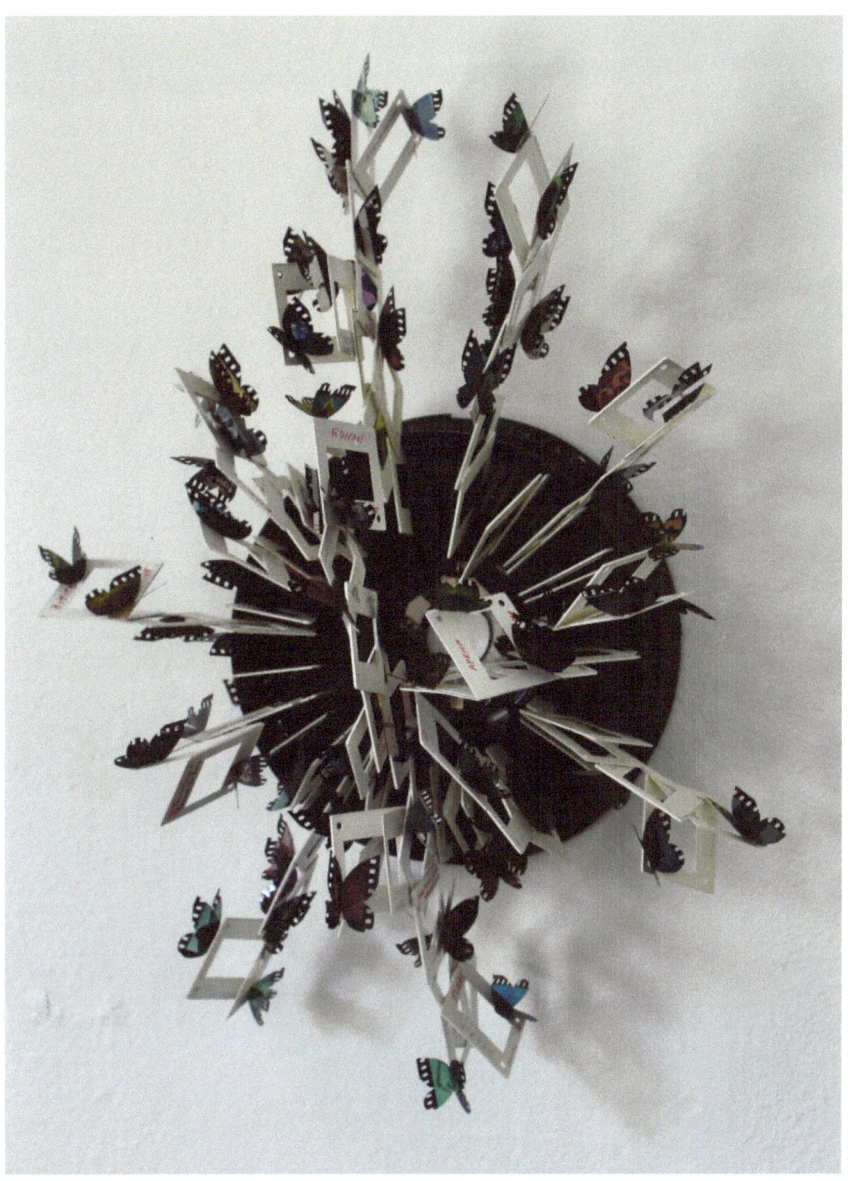

Departure 3
film, slide holders and carosel
2017

June, 2017

Tracey Weiss

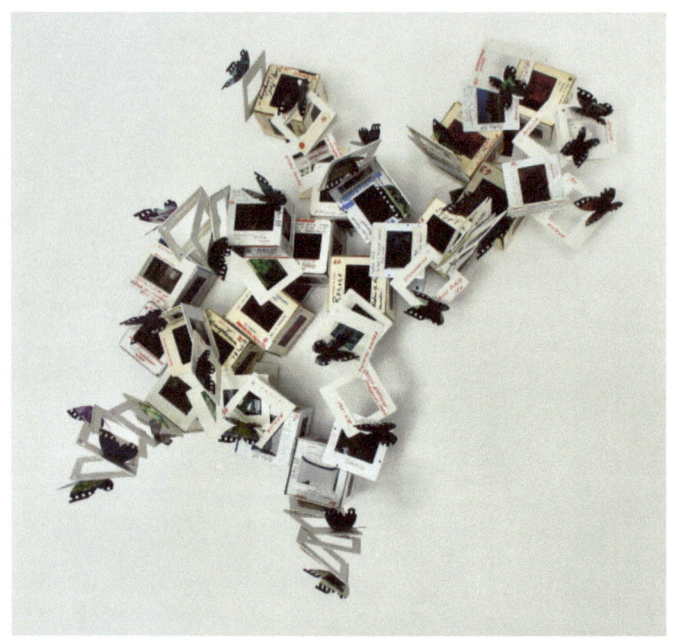

Metamorphosis 1
film, slide holders
2017

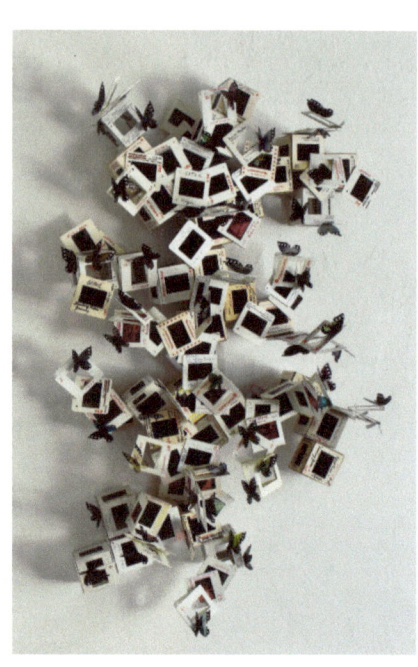

Metamorphosis 2
film, slide holders
2017

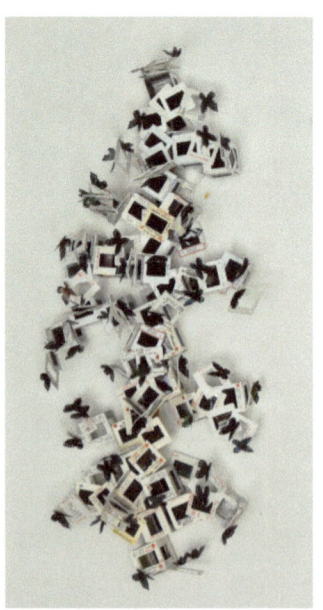

Metamorphosis 3
film, slide holders
2017

The Nature of Things

Tracey Weiss

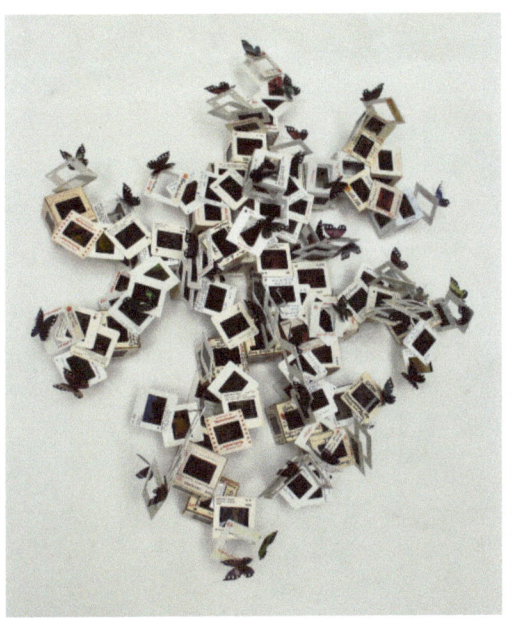

Metamorphosis 4
film, slide holders
2017

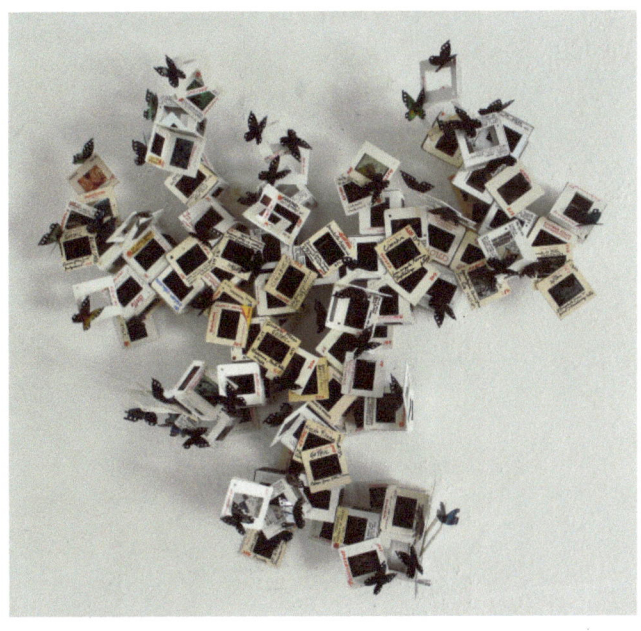

Metamorphosis 5
film, slide holders
2017

June, 2017

Tracey Weiss

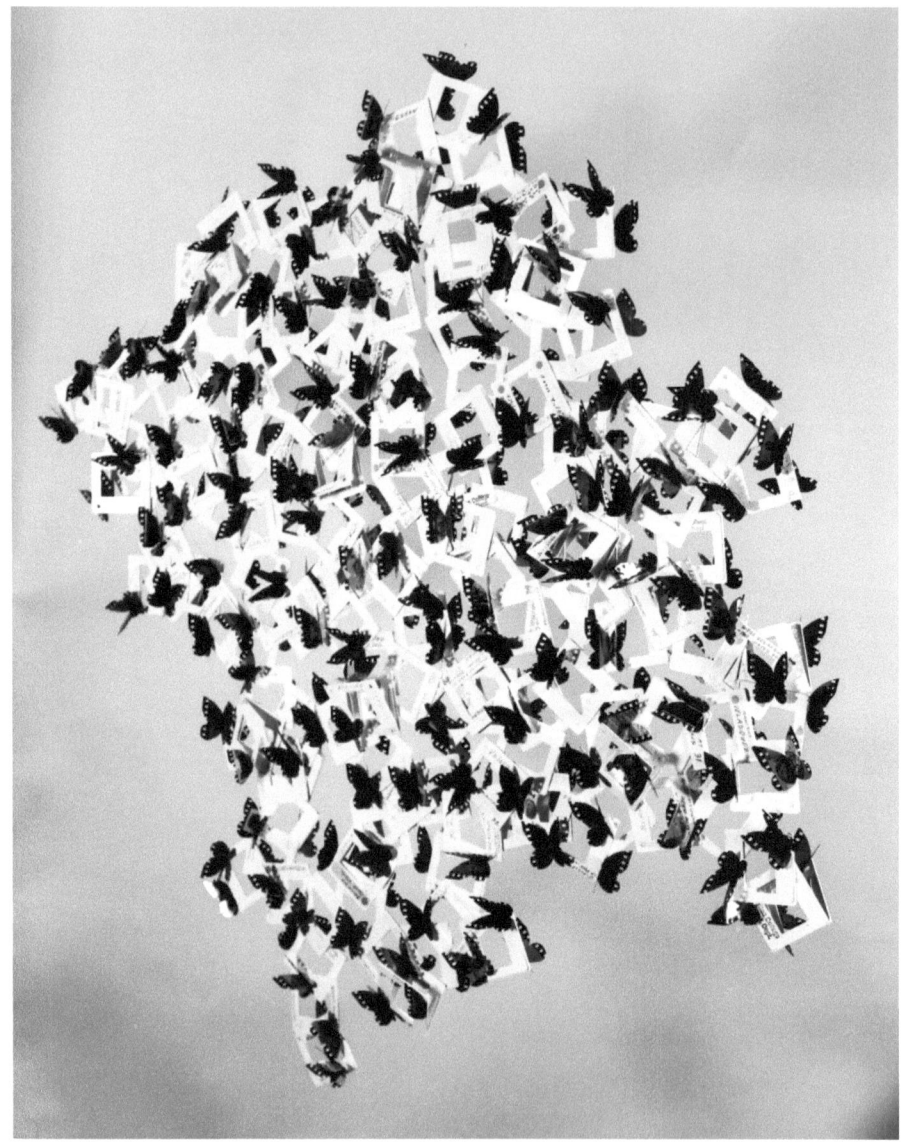

Gathering
film, slide holders
2017

The Nature of Things

Tracey Weiss

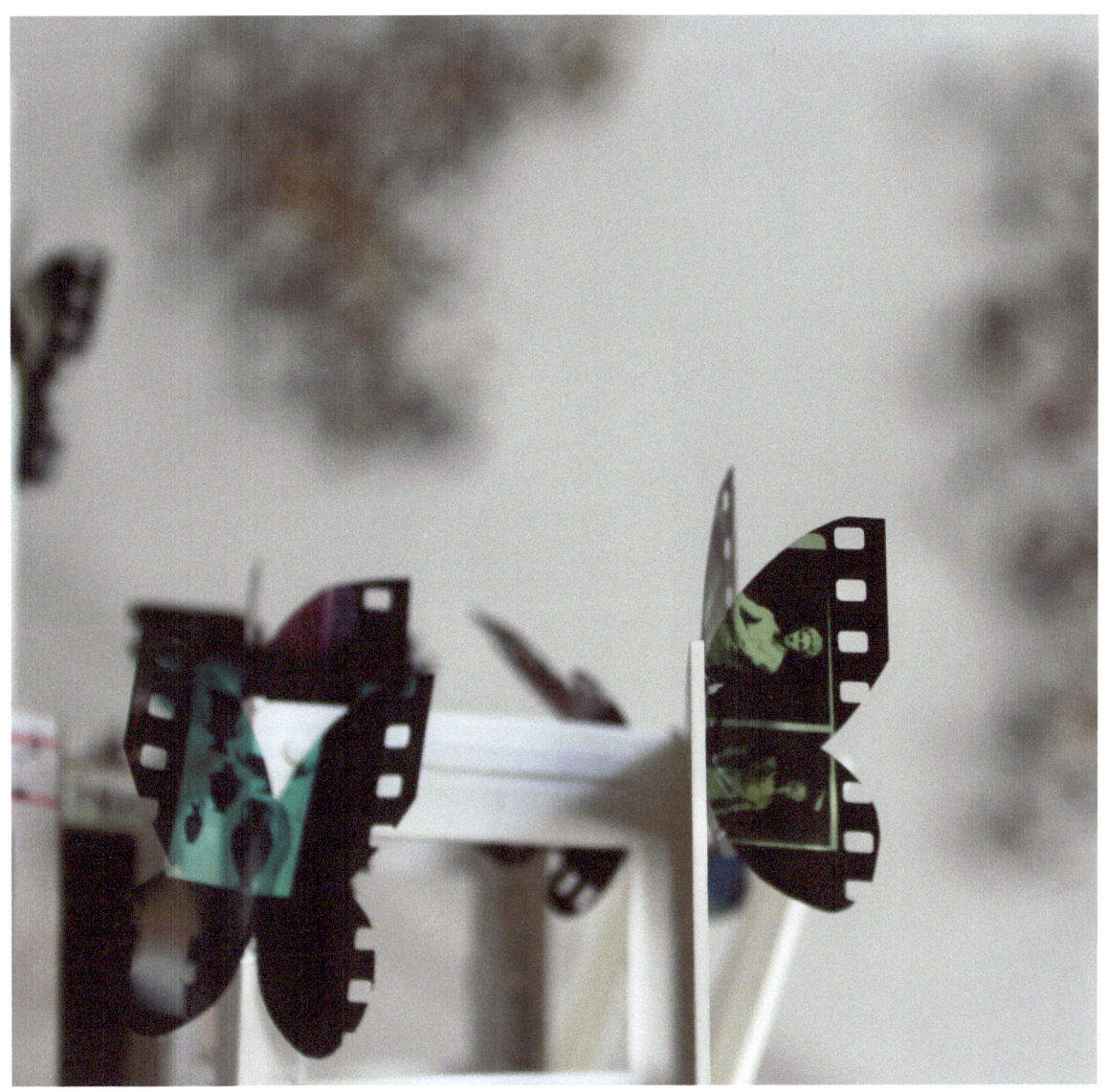

June, 2017

The Nature of Things

Karrie Ross

Gallery C:

"Balance & Flow" continues the questions for how exposure to higher vibrations, deep thinking, and taking actions are able to twist perception and create the ability to make conscious choices affecting personal growth. Art is a powerful influencer. Art that encourages choice creates a kinetic pull in such a way that it takes the action of 'walking away' from it to realize something changed and a safe place using space/time experiences now exists. "Balance & Flow" presents the experience of the "letting go" in her abstract paintings, paired with the introspection of her 3D figurative installation on the 5 Elements—together offering choices and reflection of 'what is' and 'what's next'—as a rock is to a stream, intentionally balancing conflict—allowing a sense of magic, inherent beauty.

Karrie Ross is a Los Angeles based visual artist/painter, who offers choices, and a sense of 'safe' through paintings, and interactive installations. She is a survivor.

www.karrierossfineart.com

Karrie Ross

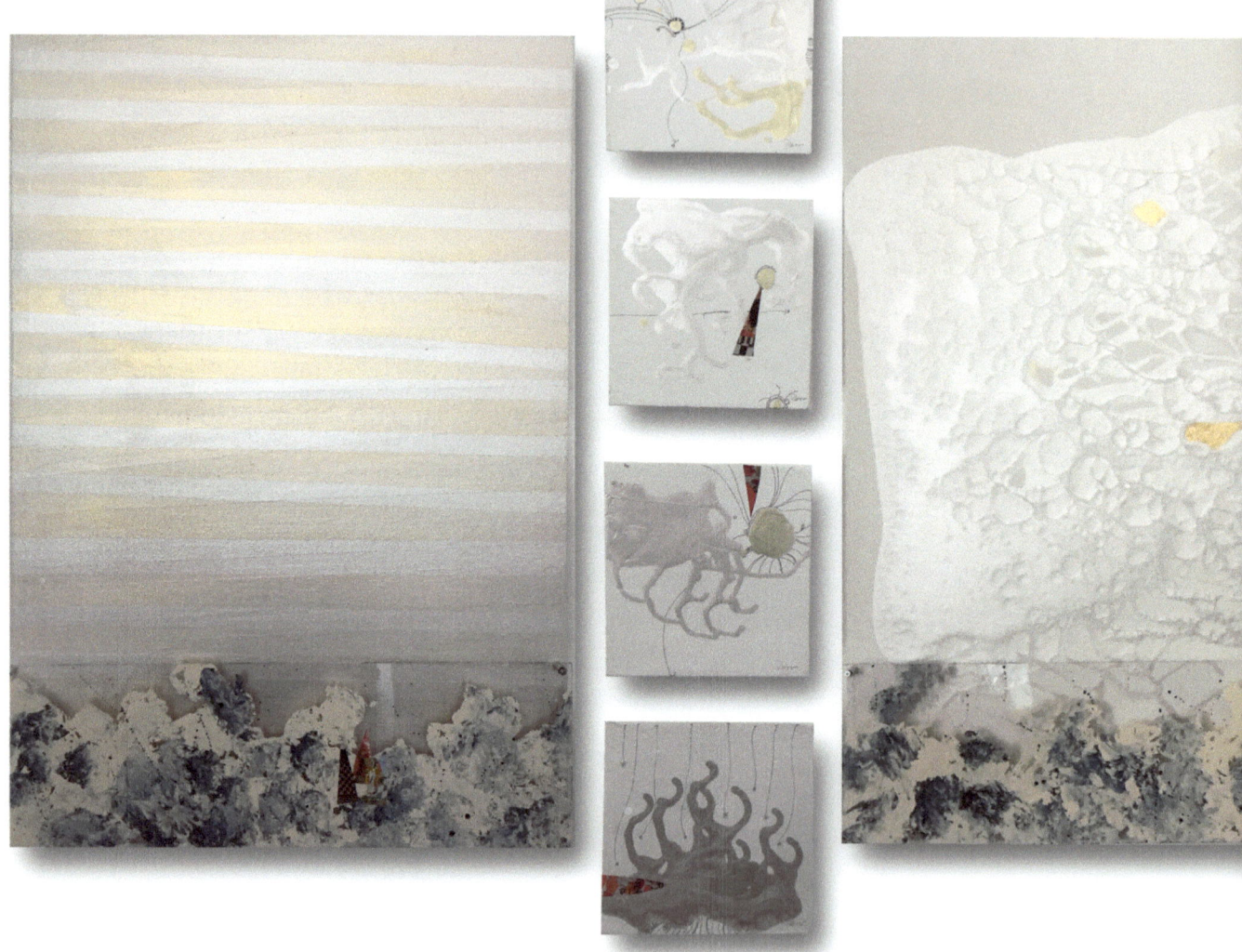

The Balance of Flow: Evolved
40" x 115"
mixed media
2017

The Nature of Things

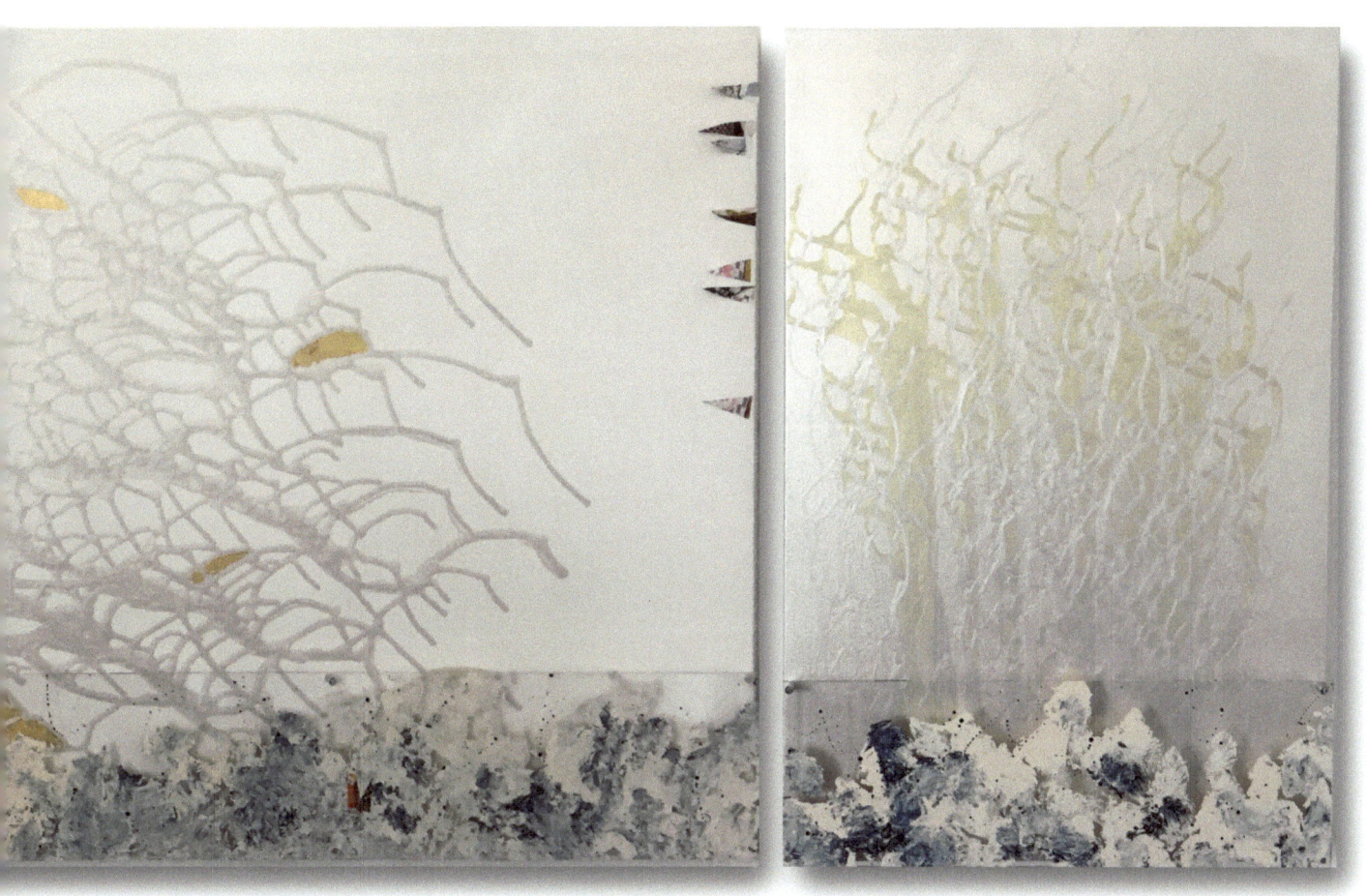

June, 2017

Karrie Ross

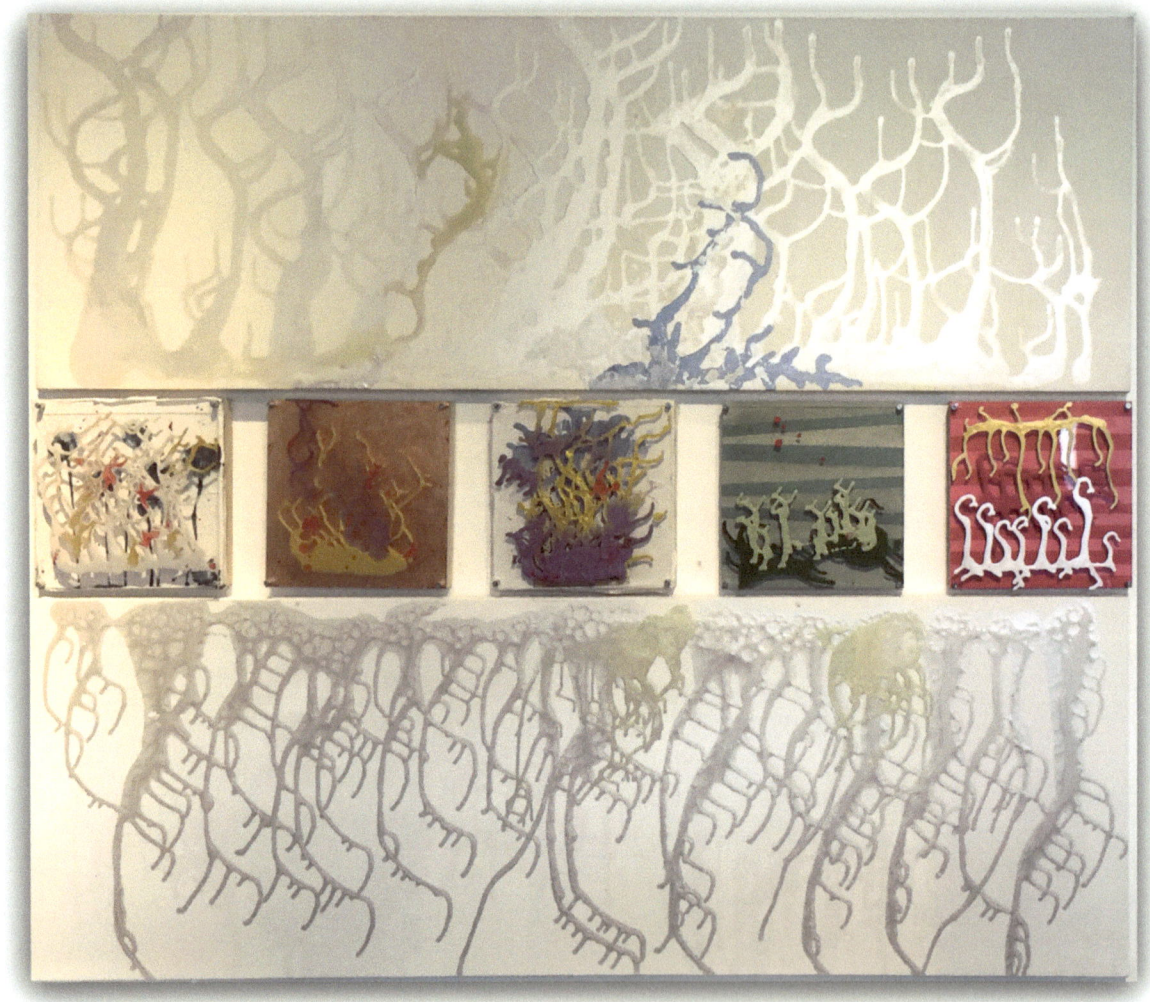

The In-Between: Balanced
60" x 72"
mixed media / modular pieces mix and match
2017

The Nature of Things

Karrie Ross

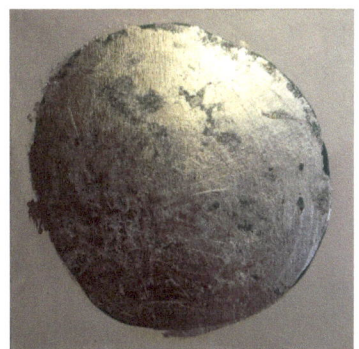

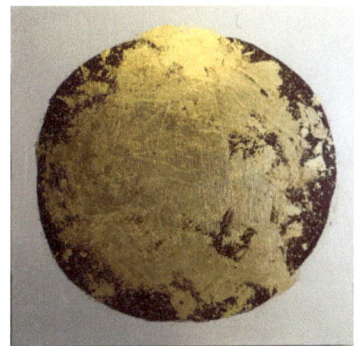

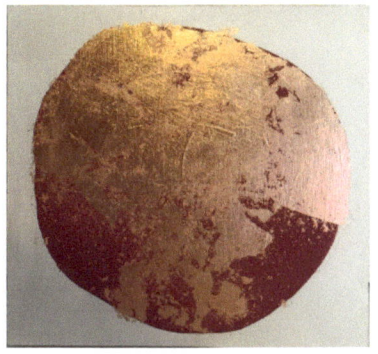

Crystal Ice
58" x 48"
acrylic, metal leaf
2017

Ice Dots: silver, gold, copper
12" x 12"
mixed media
2017
sold separately

June, 2017

Karrie Ross

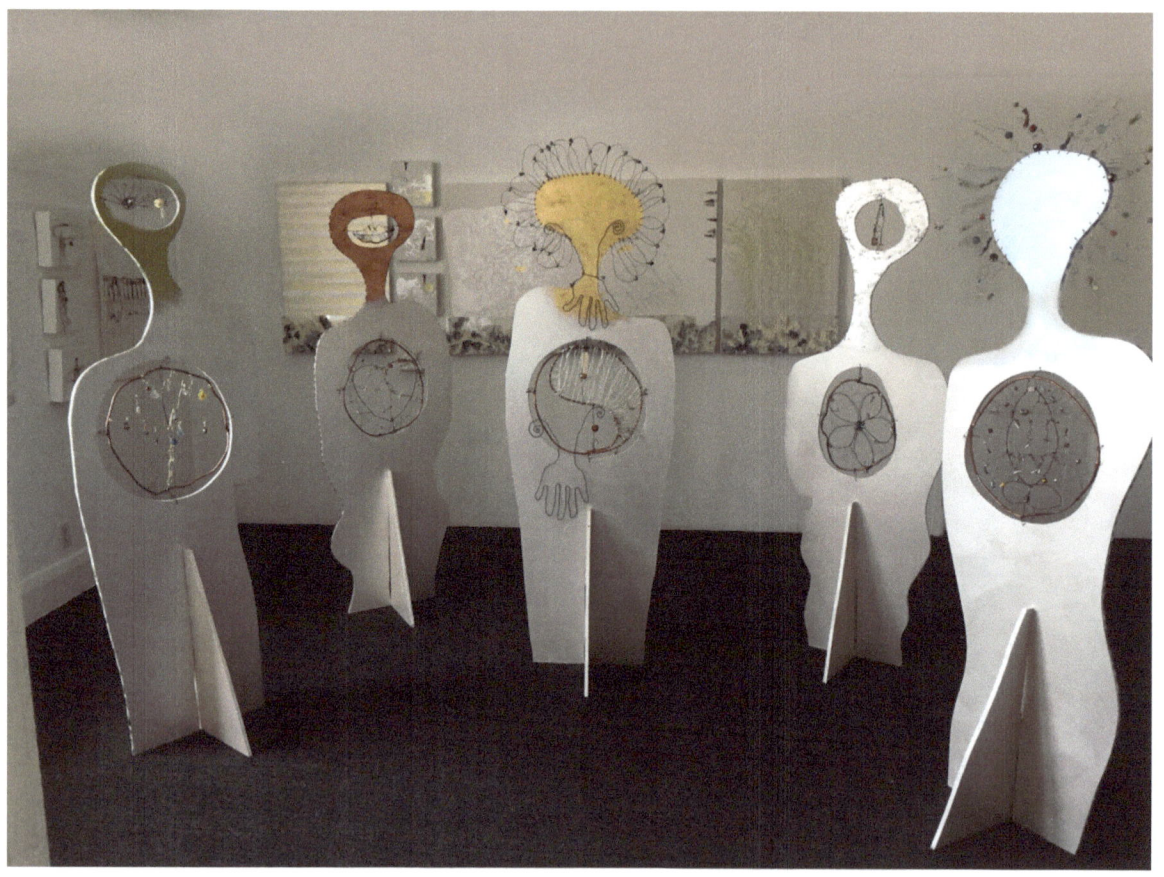

The 5 Elements: Wood, Fire, Earth, Metal, Water
72" x 24"
wood, wire, acrylic, metal leaf, beads
2017

The Nature of Things

Karrie Ross

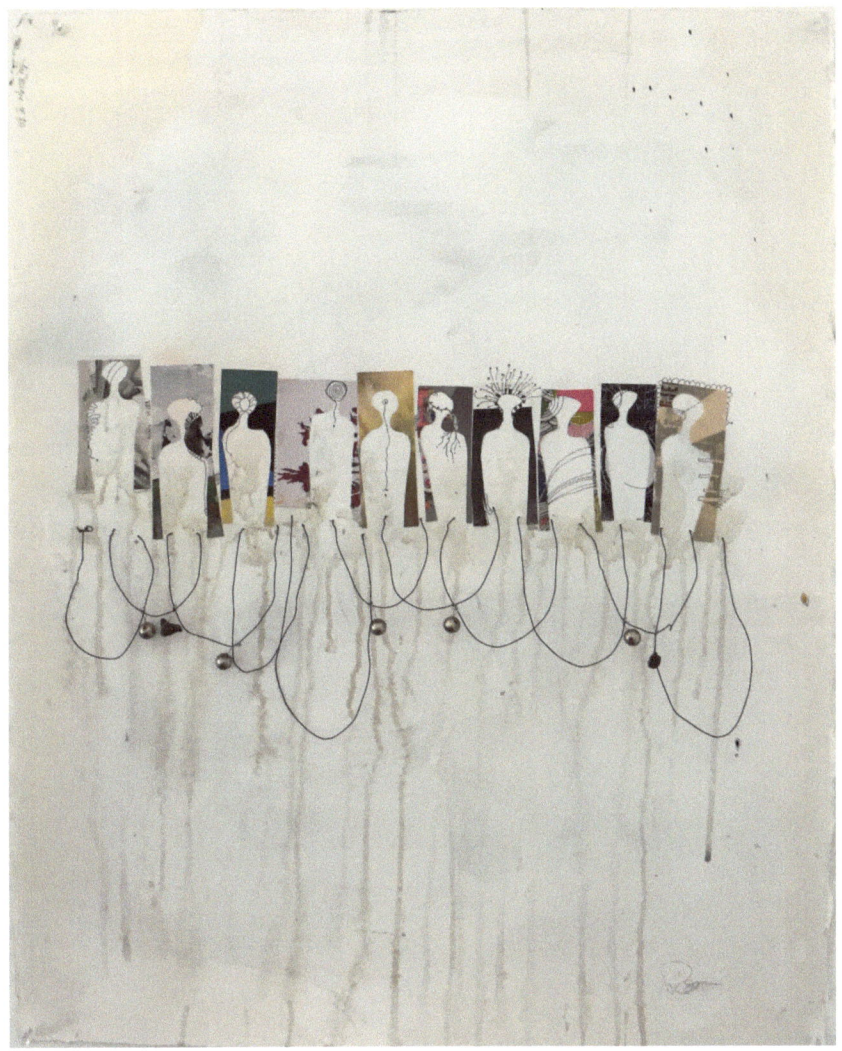

The One: The Magic of 10
30" x 22"
mixed media
2017

June, 2017

Karrie Ross

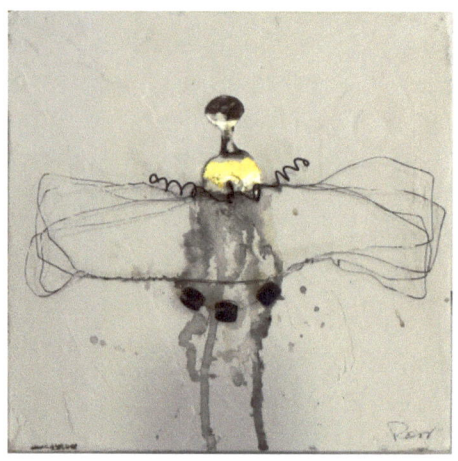

The One With Wire #1
9" x 9"
mixed media
2017

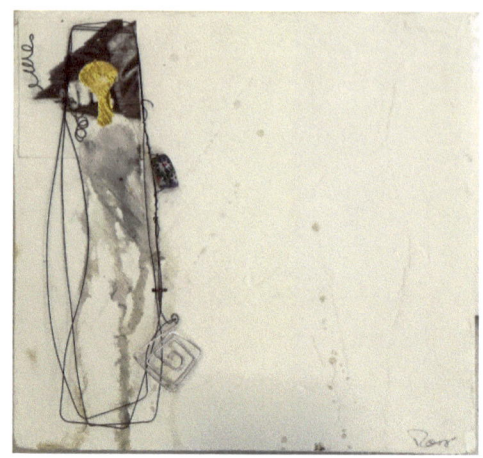

The One With Wire #2
9" x 9"
mixed media
2017

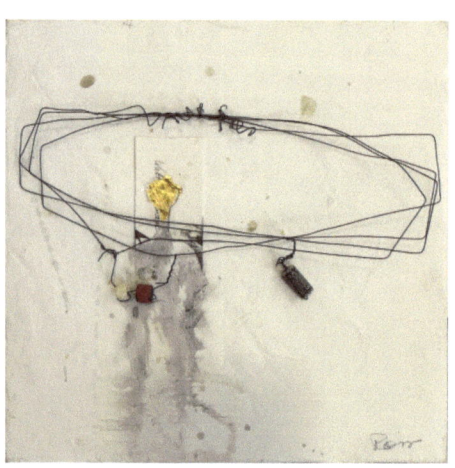

The One With Wire #3
9" x 9"
mixed media
2017

The Nature of Things

Karrie Ross

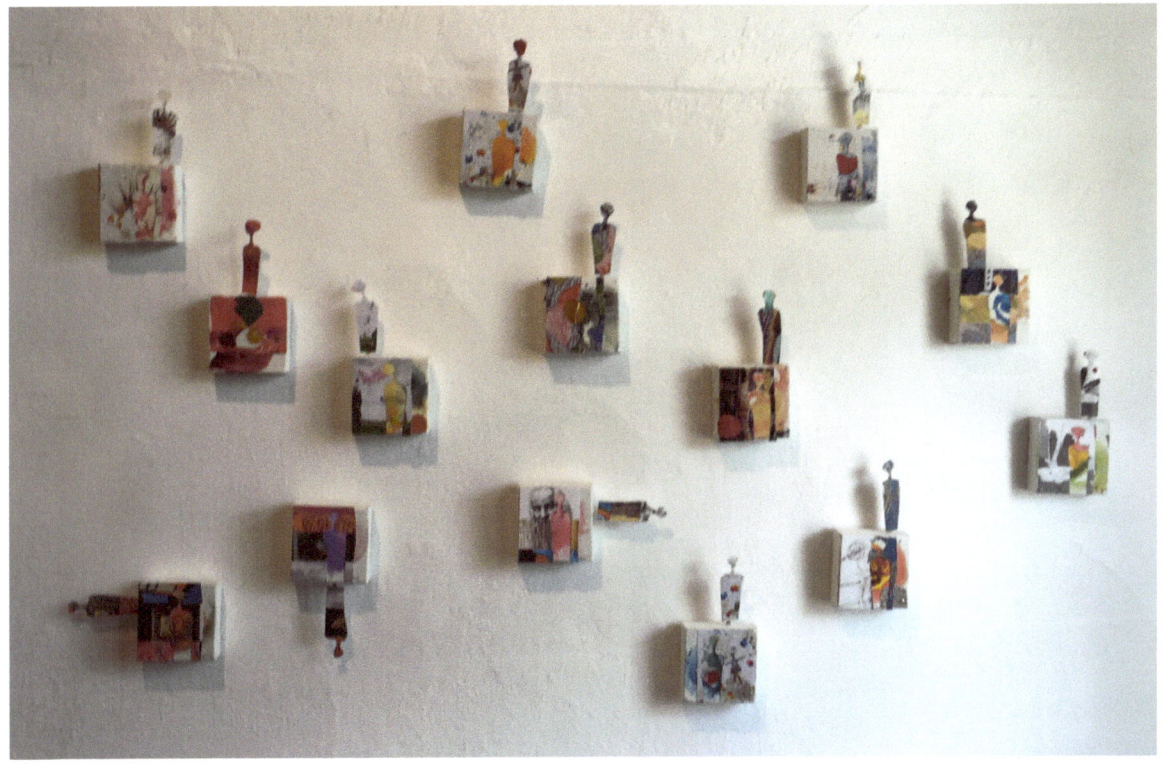

The One On A Stick
4" x 4" base with 8" stick
mixed media
2017

June, 2017

The Nature of Things: Gallery A: Lillian Abel

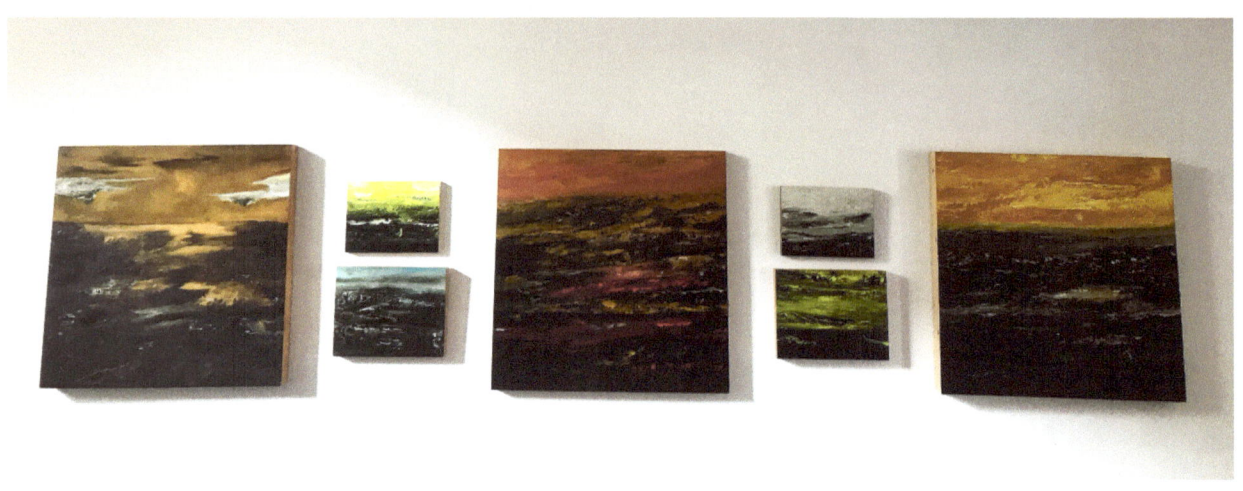

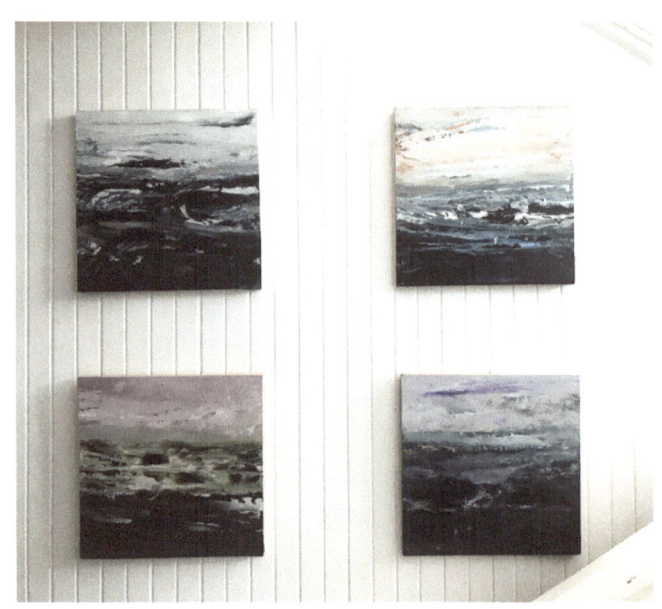

The Nature of Things: Gallery B: Tracey Weiss

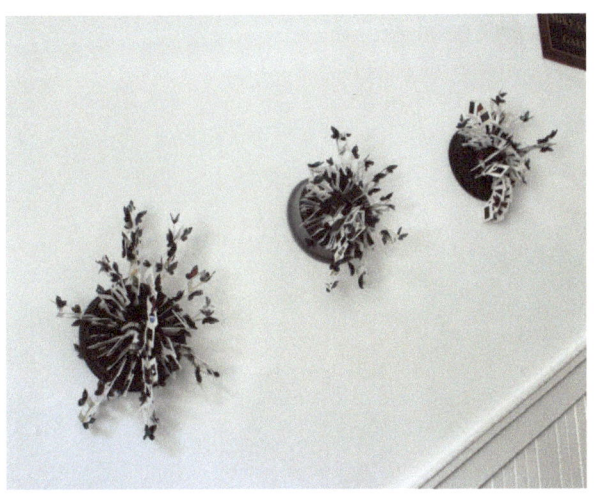
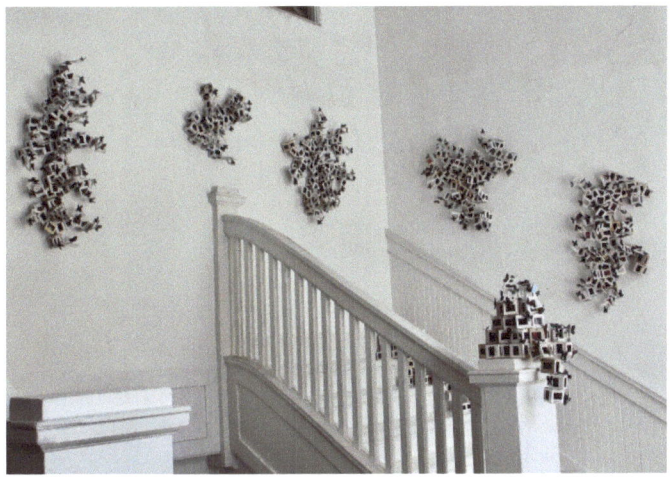
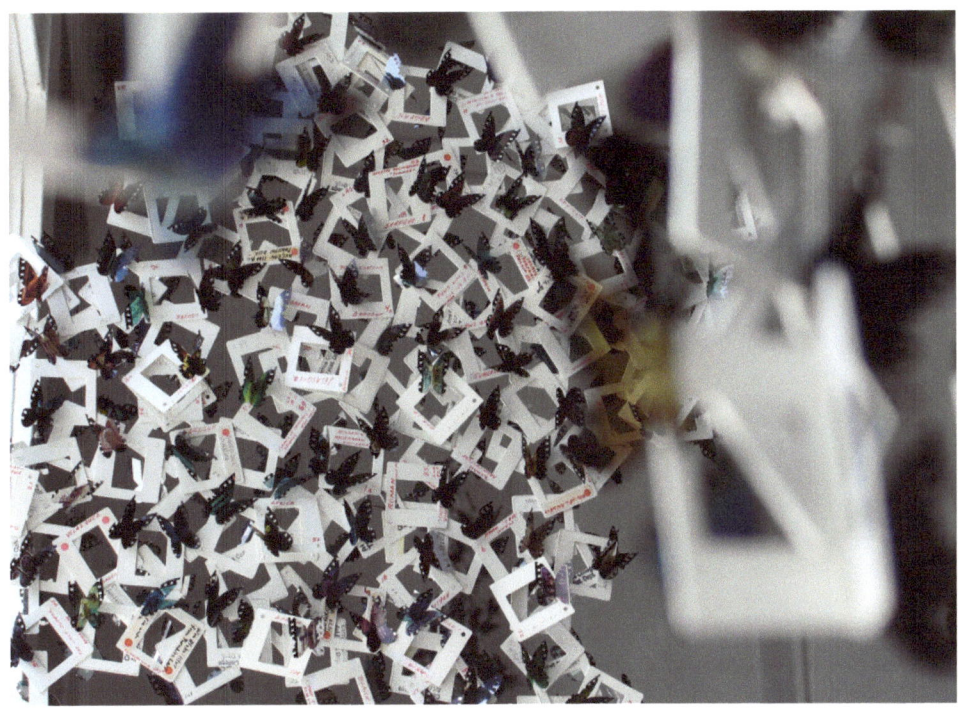

June, 2017

The Nature of Things: Gallery C: Karrie Ross

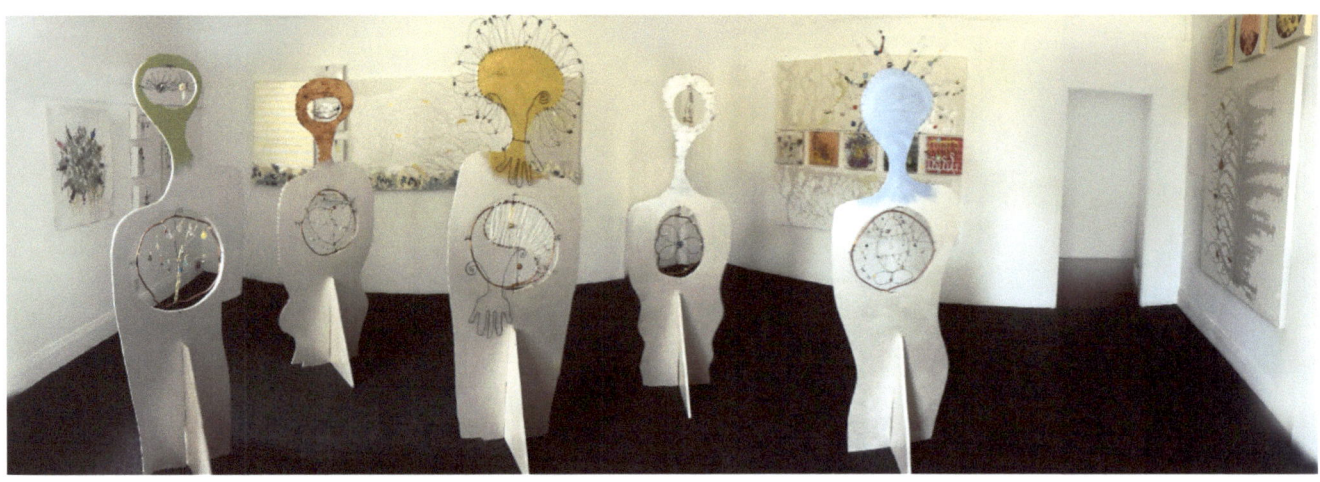

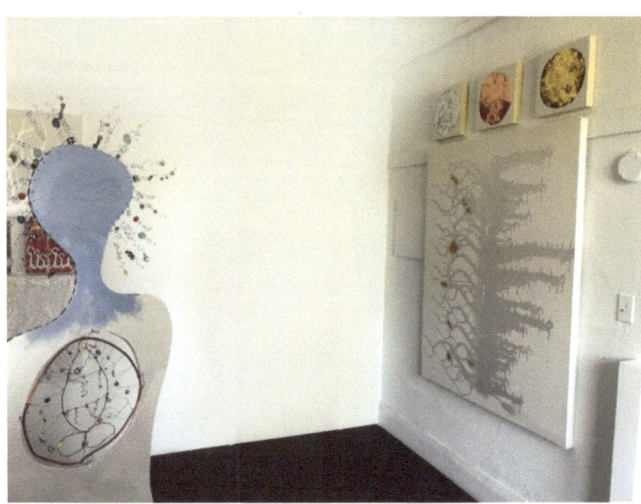

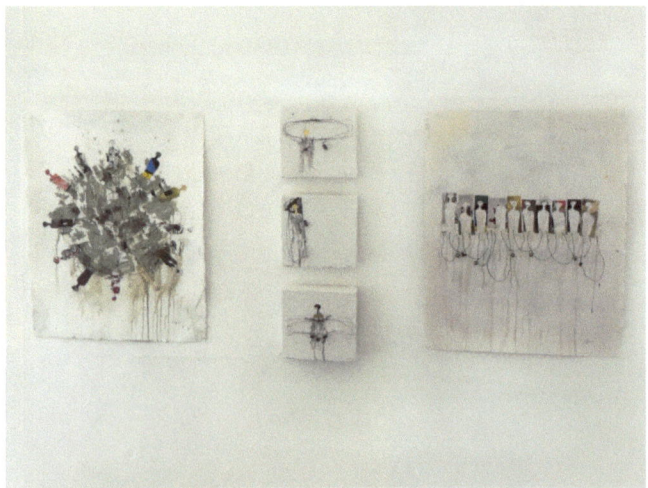

The Nature of Things